The Beginner's Guide to
Chinese Painting

Vegetables and Fruits

by Mei Ruo

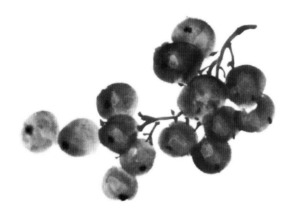

Better Link Press

This book is edited and designed by the Editorial Committee of *Cultural China* series

Managing Directors: Wang Youbu, Xu Naiqing
Editorial Director: Wu Ying
Editor (Chinese): Shen Xunli
Editor (English): Zhang Yicong
Editing Assistant: Jiang Junyan, Abigail Hundley

Text by Mei Ruo
Translation by Yawtsong Lee

Interior and Cover Design: Yuan Yinchang, Li Jing, Hu Bin

ISBN: 978-1-60220-111-8

Address any comments about *The Beginner's Guide to Chinese Painting: Vegetables and Fruits* to:

Better Link Press
99 Park Ave
New York, NY 10016
USA
or
Shanghai Press and Publishing Development Company
F 7 Donghu Road, Shanghai, China (200031)
Email: comments_betterlinkpress@hotmail.com

Printed in China by Shanghai Donnelley Printing Co. Ltd.

3 5 7 9 10 8 6 4 2

Contents

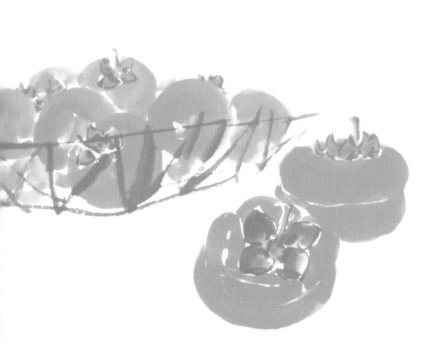

Preface

Among the many subjects of Chinese flower-and-bird painting, vegetables and fruits constitute a major sub-genre. These are common farm crops and popular non-staple food. New varieties constantly swell their already impressive ranks.

An artist will be unable to achieve artistic effect if he/she tries to paint these common objects from a general impression. There are color and morphological variations even in one fruit across cultivars, soil types, and planting and cultivation methods. Watermelons, apples and tomatoes may all be round in shape but they are round in their own distinctive ways. To do artistic justice to the vegetables and fruits with masterly ease, one must supplement painting skills with real life experience with these plants.

To give a painting of vegetables and fruits a sense of mass, artists preponderantly resort to side-brush strokes and dry brushes. The high water content of vegetables and fruits also entails a more relaxed brush manner, which does a better job of giving a sense of plumpness to the subject.

Leaf Vegetable

Painting vegetables and fruits involves a great deal of centered-tip and side-brush strokes; it requires the use of larger-size brushes and nuanced shades of ink and color. The majority of leaf vegetables are roughly shaped as shown in the diagram, with stalks bearing green leaves shooting up from the root. Use dark ink to paint the leaves, which are deeper in shade. They should not be uniformly dark but nuanced to give depth and a three-dimensional feel. A characteristic in the drawing of lines in Chinese painting is that they are directly proportional to the bulk of the object. The leaf stalks taper from the root toward the leafy top and therefore the lines should also become finer as they approach the tip. When using color, the brush should be soaked in water to its base and tipped with dark ink. Paint the leaves in side-brush strokes to bring out shade variation. Outline the leaf veins in dark ink.

Painting leaf vegetables assorted with mushrooms

1. Use a brush rinsed in clear water and tipped with dark ink to outline the leaf stalks; remember the importance of variation in line thickness and

contrast in the density of the composition (Figures 1-3).

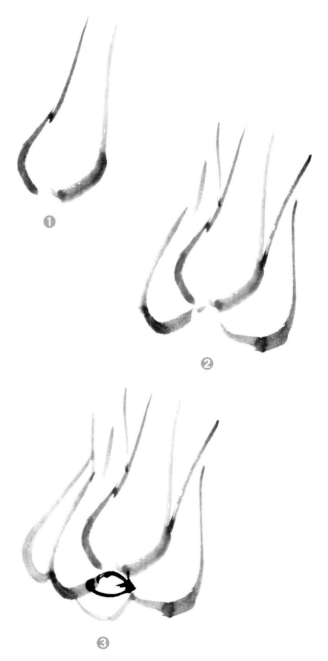

6

2. Paint the leaves in a combination of dark, light, dry and wet ink and color. Apply the centered-tip stroke, segueing into the side-brush stroke so that the clear water contained in the base of the brush will ooze out to make the ink and color more vibrant. Nuanced shading of the leaves will give them a moist and translucent look (Figures 4-7).

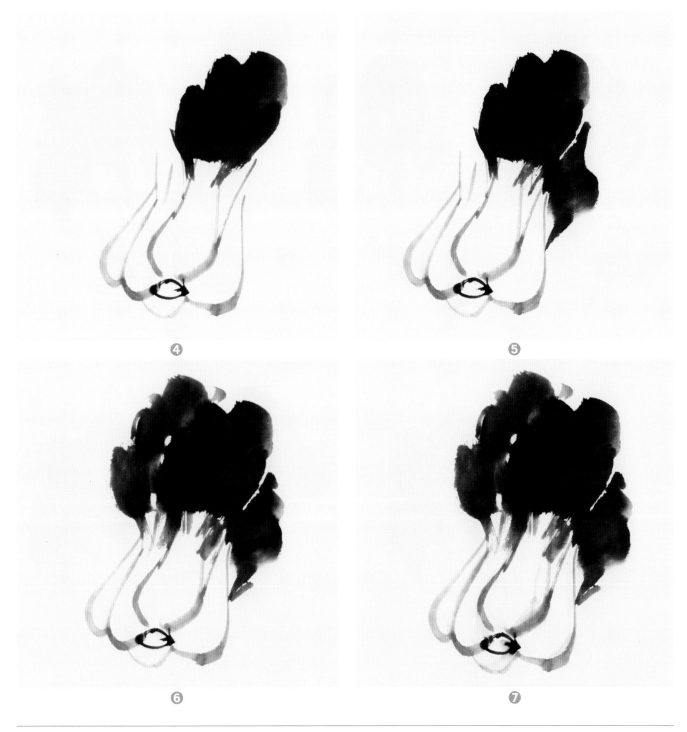

④

⑤

⑥

⑦

3. Dab the leaf stalks in a few spots with a pale green made by mixing gamboge and cyanine to give volume (Fig. 8).

4. Before the leaves dry, outline the leaf veins (Fig. 9).

5. Paint the second vegetable in lighter ink, following the preceding steps (Figures 10-12).

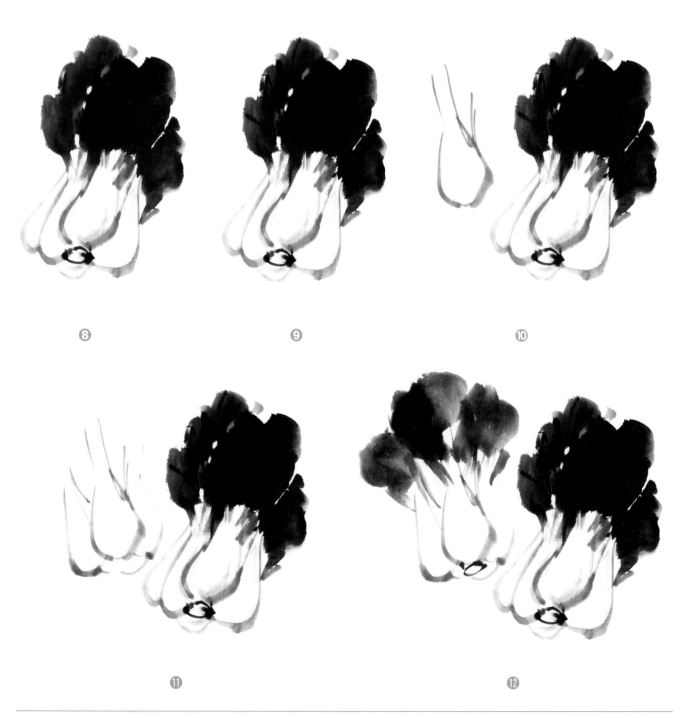

⑧　　　　　　　　⑨　　　　　　　　⑩

⑪　　　　　　　　　　　　　⑫

6. Adding mushrooms to the picture will liven it up. Use a stiffer brush to paint the mushrooms, applying the centered-tip stroke. Dip the brush in clear water generously mixed with ocher and tip it with dark ink to paint the sides of the mushroom in one stroke (Fig. 13); use a partially dried brush to paint the stem of the mushroom, and outline the spore pattern (Fig. 14). Use side-brush strokes to paint the second and third mushrooms (Figures 15-17).

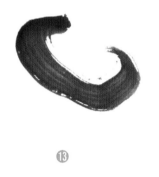

⑬

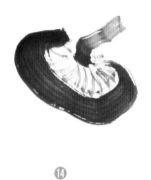

⑭

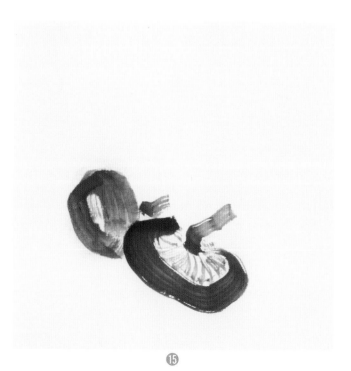

⑮

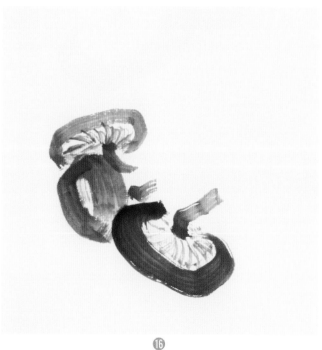

⑯

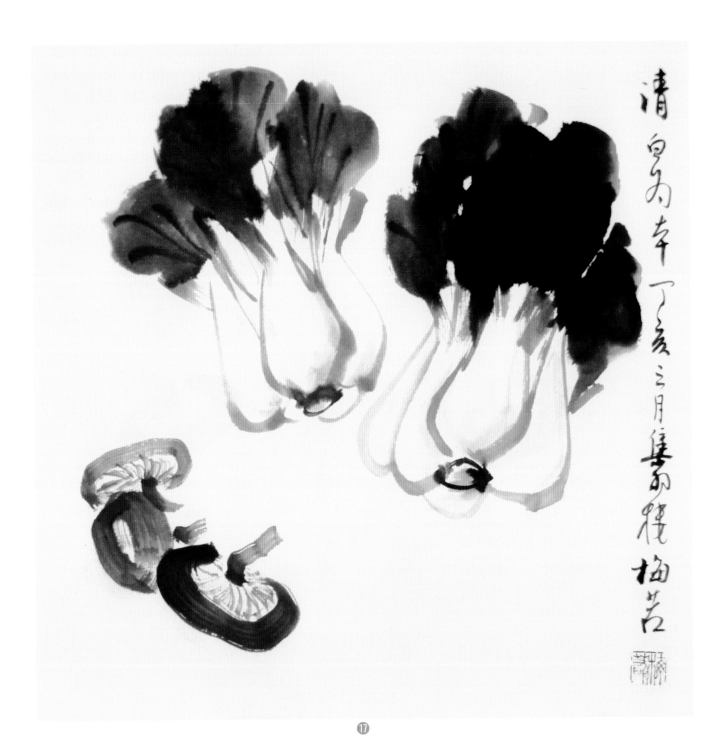

⑰

Turnip and Carrot

To paint carrots, beets, radishes and turnips, use side-brush strokes to evoke a sense of mass.

Painting long turnips

1. Outline the long turnip with a brush tipped with medium-shade ink, partially using the side-brush stroke (Fig. 1).

2. Touch up sideways in side-brush strokes at selected spots along the turnip, making sure the markings are slightly curved to impart a sense of three-dimensionality and roundness to the turnip (Fig. 2).

3. To enrich the pictorial composition, add a turnip, using yellowish dark green to paint the leaf stems; apply some white powder to make the turnips appear paler (Figures 3-4).

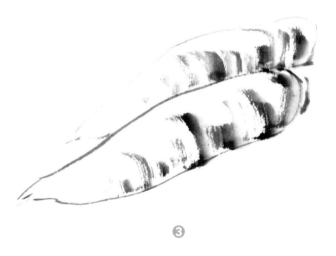

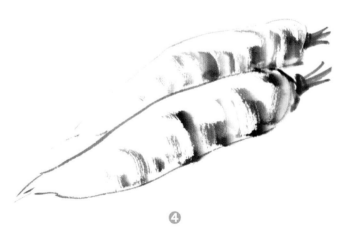

Painting red turnips

1. Paint across the paper with a brush saturated with clear water and tipped with a little eosin in one side-brush stroke, remembering to apply only light pressure, with most of the force concentrated at the base of the brush (Fig. 1).

2. The second and third strokes slightly overlap the preceding one. Complete the left half of the turnip in three strokes; start from right to left to finish the right half, also in three strokes. Add the root hairs using centered-tip strokes. Remember the importance of variation in color and ink shading, and in wetness of the brush (Fig. 2).

3. Add more red turnips by following the same steps as described above. Paint in centered-tip strokes the leaf stems with a brush dipped in dark green and tipped with rouge. Paint the leaves with the brush dipped in dark green and tipped with dark ink; and finally outline the leaf veins in ink (Figures 3-6).

❶ ❷

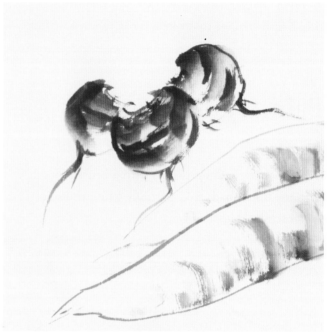

❸

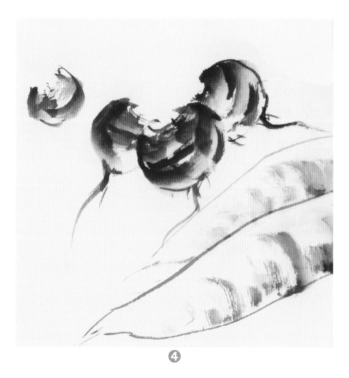

❹

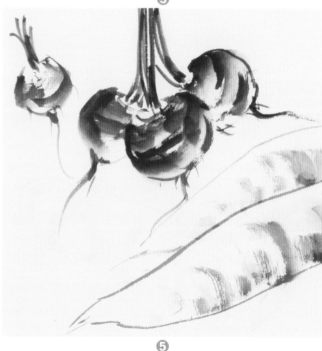

❺

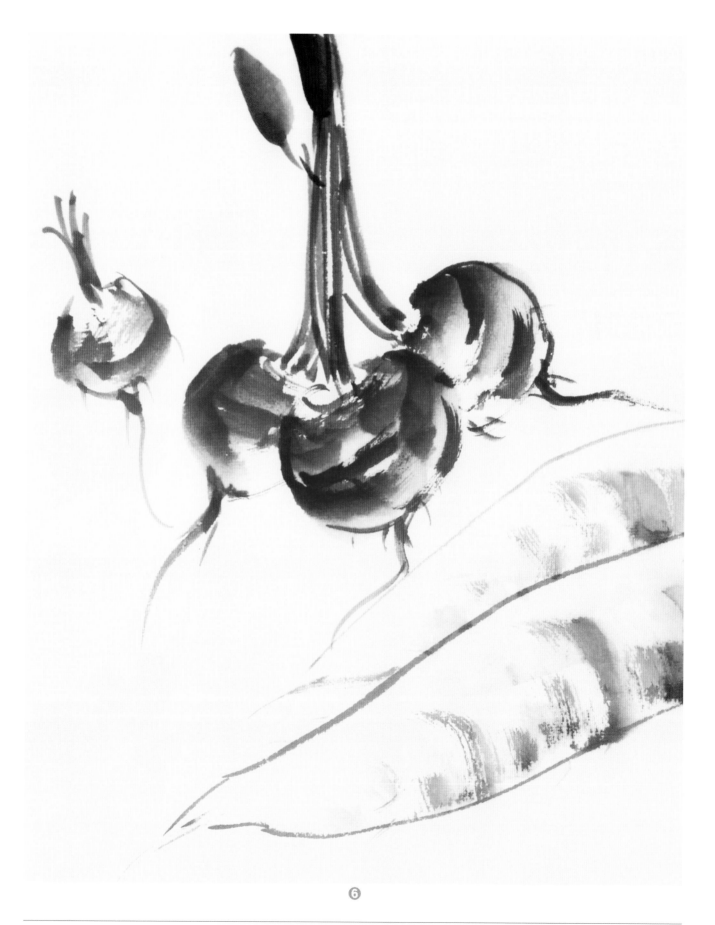

Painting carrots

1. Dip a brush saturated with water in gamboge up to the base, and then dip it in orange red. Remember not to mix with other colors. Paint the head first, outlining the carrot in two strokes (Fig. 1).

2. Use slightly arced, side-brush strokes to paint in the body of the carrot, remembering to leave "flying white", the broken ink washes (Fig. 2).

3. Use dark green (mixed from gamboge and cyanine) to fill in leaf stems of varying lengths at the head, and maybe add in a few leaves. Follow the same steps to add another carrot (Figures 3-5).

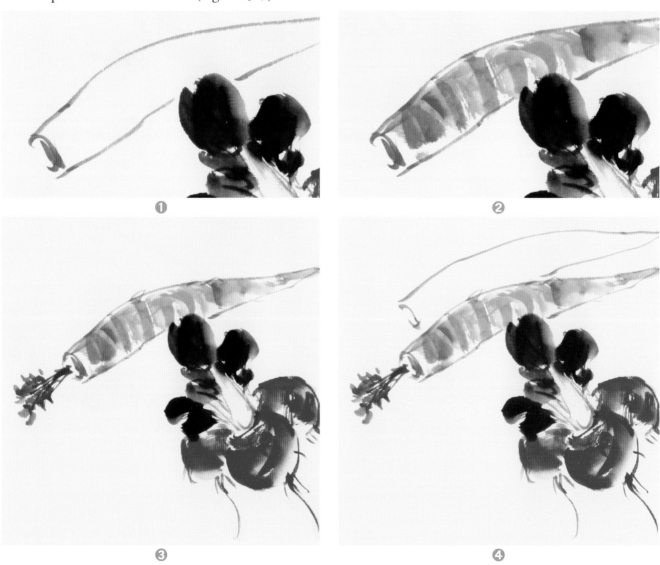

❶ ❷

❸ ❹

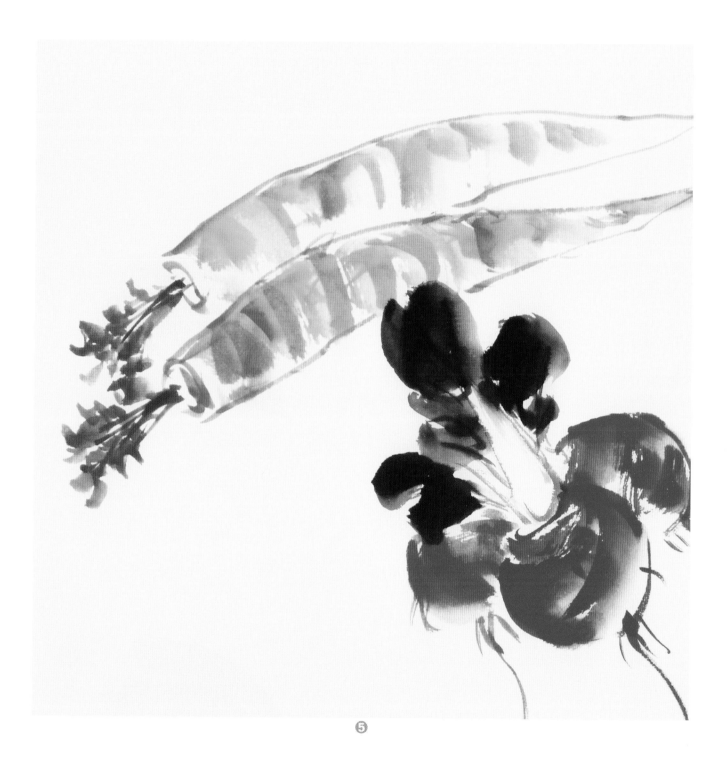

Bamboo Shoot

Bamboo shoots come in a wide variety: winter bamboo shoots, common bamboo shoots and *mao* bamboo shoots are some examples.

Painting winter bamboo shoots

1. Winter bamboo shoots are shorter. Paint with a brush dipped in ocher and tipped with dark ink; paint from the tip of the shoot to its bottom (Fig. 1).

❶

2. Paint the tip first; alternate right and left when painting the sheaths, keeping the lines slightly curved (Fig. 2).

❷

3. Outline the root at the bottom (Fig. 3).

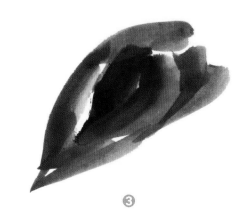

❸

4. Use dark ink to dot the tiny protuberances on the root. Outline the stripes on the sheaths before the ink dries and avoid making them too even and uniform (Fig. 4).

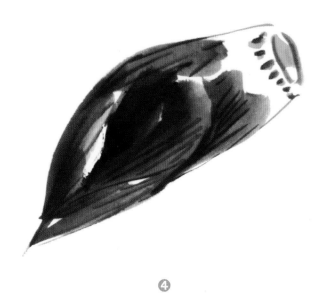

❹

5. Add another winter bamboo shoot (Figures 5-8).

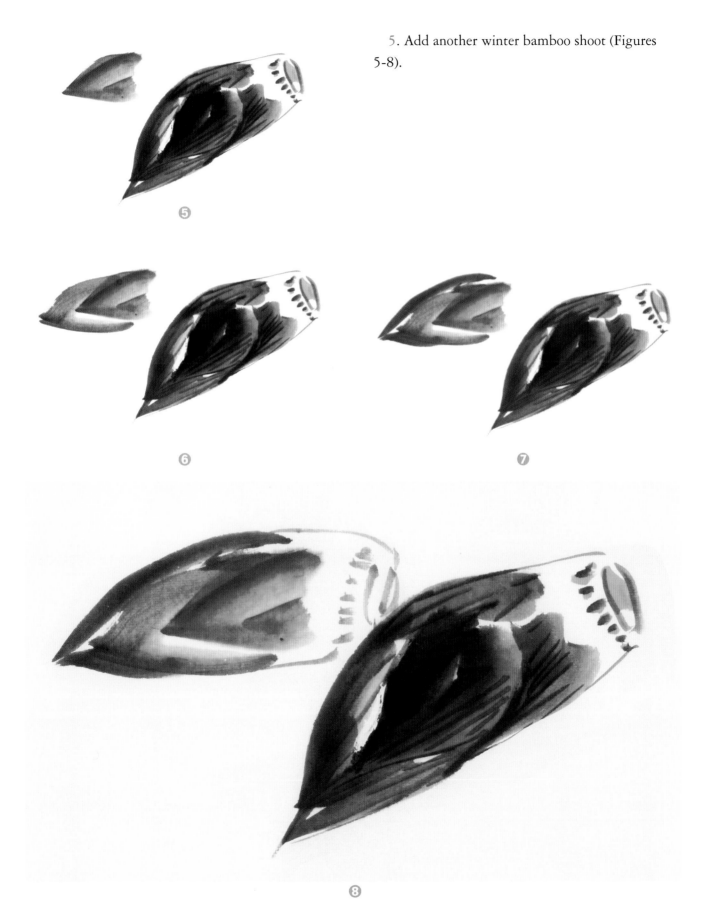

⑤

⑥

⑦

⑧

Painting common bamboo shoots

This is a slenderer variety and the technique applied to the winter bamboo shoots is largely the same. Make sure the tips of the sheaths do not form a "staircase" and that their details are not lost (Figures 1-3).

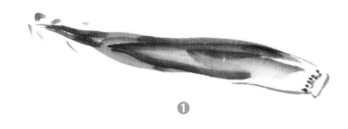

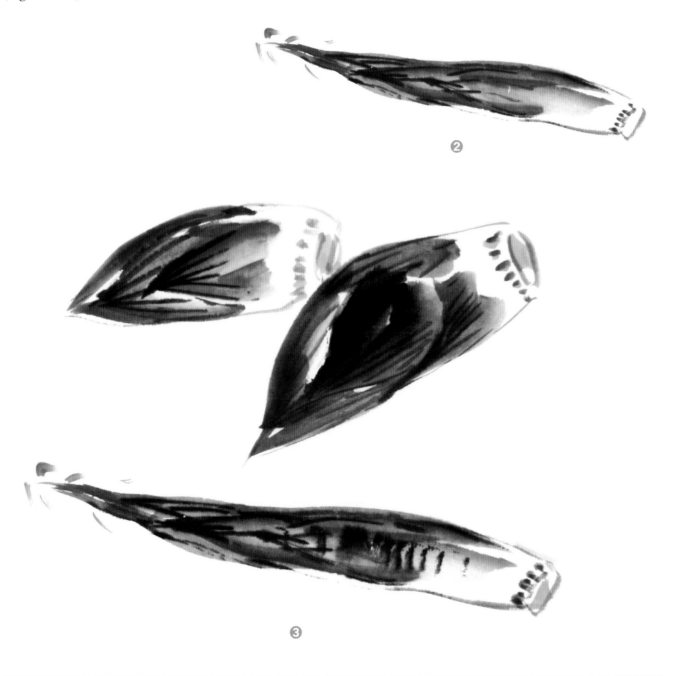

Painting *mao* bamboo shoots

The same technique applies to this thicker, bigger variety (Figures 1-4).

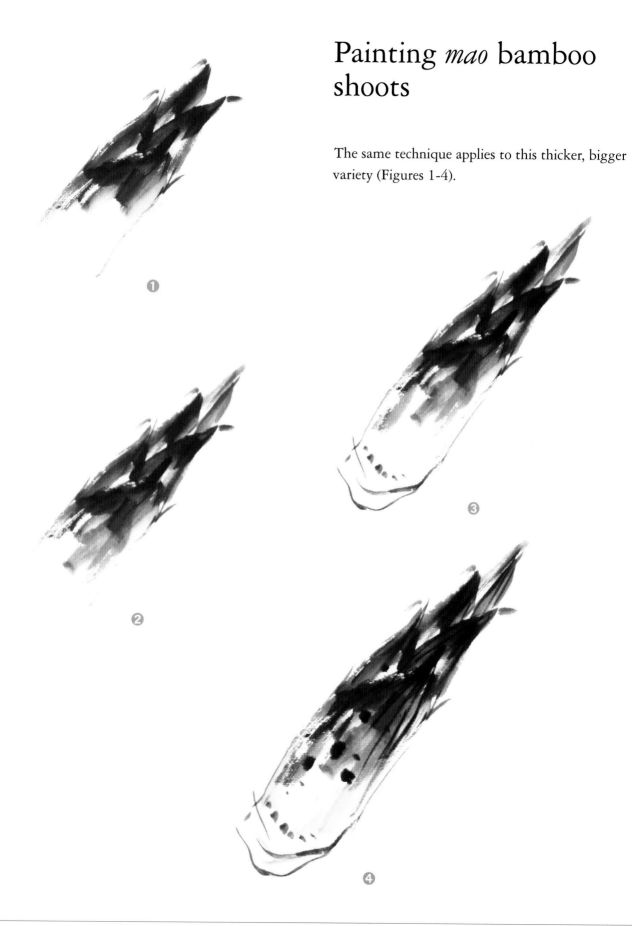

Loofah

Painting loofahs

1. Dip the brush in a yellowish dark green made
by mixing gamboge and cyanine and tip it with
cyanine to paint the shape of a loofah in centered-
tip strokes. Apply the same technique to the other
loofah (Figures 1-2).

❶

❷

2. Outline the stripes on the loofahs in dark
ink. There are two ways of painting the stripes:
the vertical brush stroke and the dragged-brush
stroke (with the brush tilted at an angle); the latter
produces a rough look and is therefore more suited
to painting stripes (Fig. 3).

❸

3. Putting loofah, *mao* bamboo shoots and tomatoes in the same picture will enrich it, adding color and enhancing esthetics (Fig. 4).

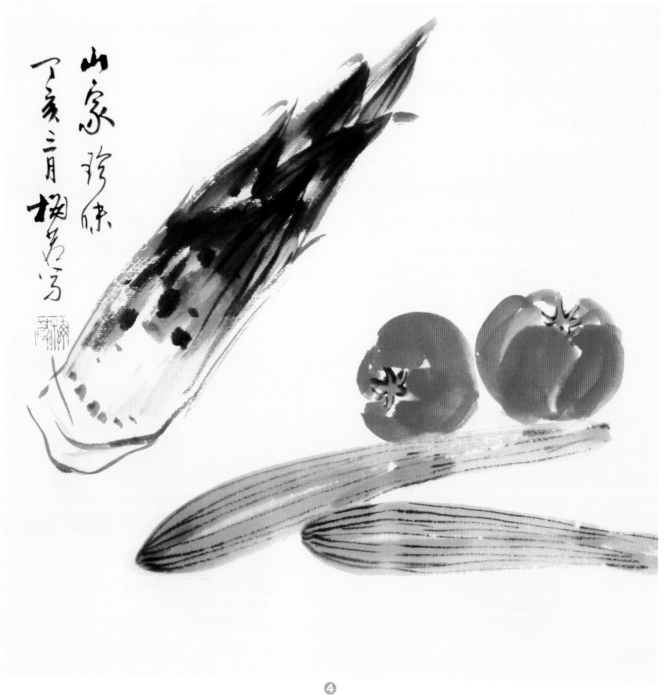

④

Eggplant

The eggplant fruit may be round or elongated.

Painting egg-shaped eggplants

1. Use reddish purple made by mixing eosin and cyanine. Since the eggplant fruit is smooth-skinned, use centered-tip strokes to paint the edge of the fruit. Do not paint the edges in side-brush strokes or with the base of the brush because that would cause the ink and color to bleed. In two strokes, outline the shape of the eggplant, leaving highlights in the middle (Fig. 1).

❶

2. Paint the stalks with a brush dipped in green (Fig. 2).

❷

3. Add another one by following the same steps. Outline the salks with the brush tipped with dark ink (Figures 3-5).

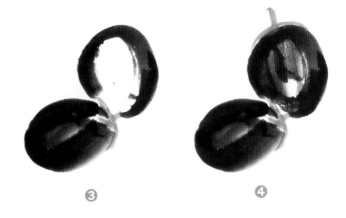

❸ ❹

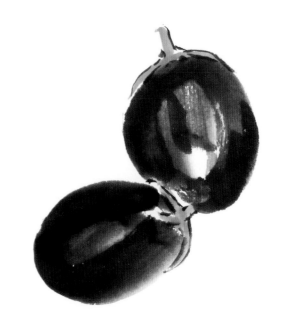

❺

Painting the elongated type of eggplant

Complete it in two strokes; use dark green to paint the stalks. Remember to use the brush in a firm, confident and unhesitating manner (Figures 1-3).

Green Bell Pepper

Sweet green bell peppers have four slightly concave sides, giving them the look of a lantern, thus the popular name of "lantern" peppers among the Chinese.

Painting green bell peppers

1. Dip the brush in a mixture of gamboge and cyanine; and then tip the brush with a small amount of cyanine to paint two sides of the pepper first; use touchup strokes near the stalk and leave highlights (Figures 1-2).

①

②

2. Paint the stalks in yellowish dark green (Fig. 3).

③

3. Without re-dipping the brush, add in two strokes the other two sides. Now the bell pepper looks three-dimensional (Fig. 4).

④

Painting green bell peppers placed at different angles

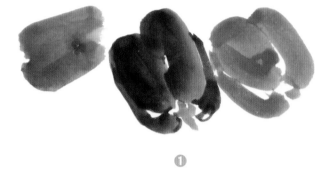

1. With a larger-size brush, one can paint one side of the pepper in one stroke (Figures 1-3).

An elongated pepper does not have the distinctive shape of a bell pepper but the color use and painting technique for it are similar to those for the bell pepper. Remember however that the color of its stalk should be a shade lighter.

❶

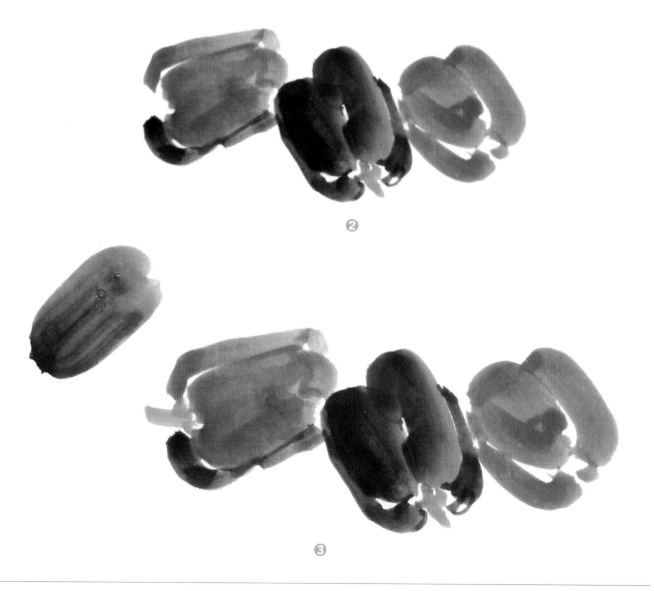

❷

❸

2. Adding eggplants to the picture will liven it up (Fig. 4).

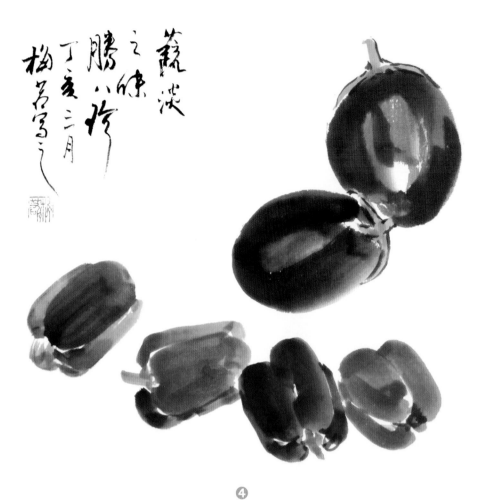

❹

Painting red peppers

Dip the brush in bright red, then tip it with rouge to paint the shape of the pepper in one side-brush stroke, making sure it has an interesting look. Another way of painting it consists of two strokes, leaving highlights in the middle to give it a fresh look (Fig. 1).

❶

Tomato

Painting a tomato

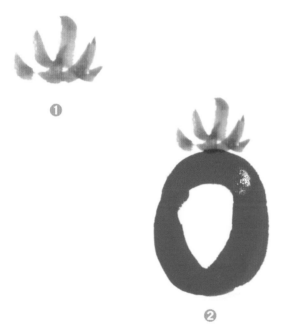

1. Use dark green made by mixing gamboge and cyanine to paint the sepals of the tomato (Fig. 1).

2. Paint one segment with a mixture of orange red and eosin, leaving highlights (Fig. 2).

3. Complete the whole body to produce a round shape, leaving spots of reflected light (Figures 3-4).

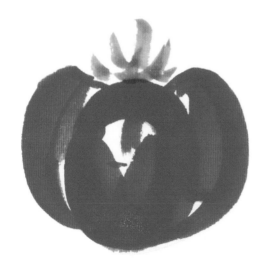

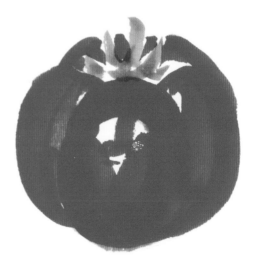

4. Add a few tomatoes and outline the sepals in dark ink (Figures 5-7).

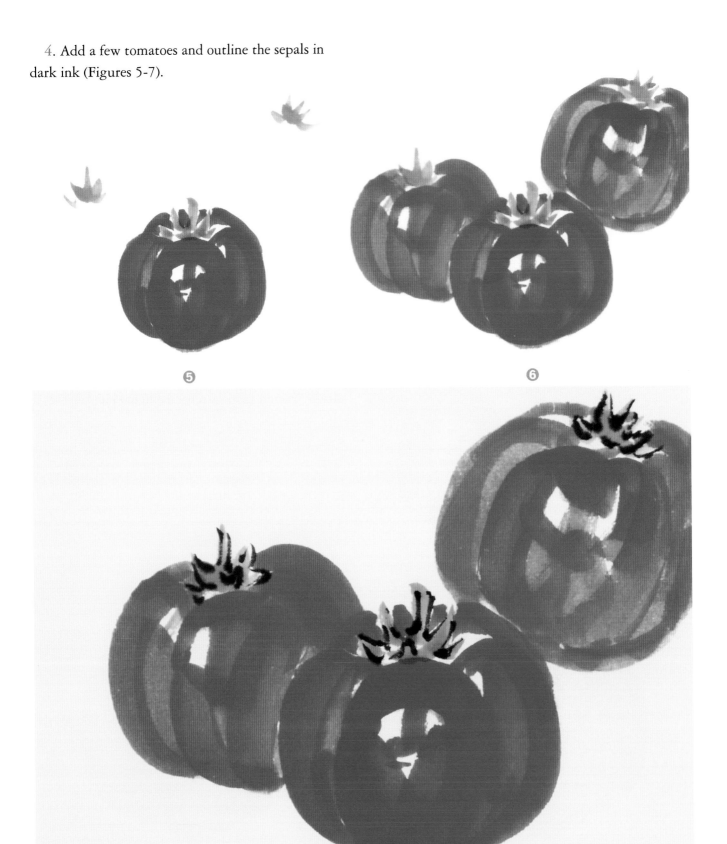

⑤

⑥

❼

Painting a tomato in the *xie yi* style

1. Use a mixture of orange red and eosin to paint the tomato, outlining it with dark ink (Figures 1-4).

2. When applying dark green, control the water content in the brush. The tomato should be smooth-edged. Since the water is concentrated in the belly of the brush, remember to keep the tip of the brush pointed toward the edge of the tomato to prevent the ink and color from bleeding across the boundary (Fig. 5).

❶

❷

❸

❹

❺

Pumpkin

Painting a pumpkin

1. The pumpkin is shaped like a lantern. When painting a full-grown pumpkin, make the stalk look rugged to bring out its age and to give mass (Fig. 1).

2. Outline the pumpkin with a dry brush (Figures 2-5).

3. The pumpkin is normally yellowish or greenish where it faces the sun and reddish or golden where it is not directly exposed to the sun. Some artistic creativity is allowed when painting the pumpkin. Apply a mixtue of orange red and bright red to the upper half of the pumpkin and dark green to the underside, with gamboge in between. Color the stalk with ocher (Figures 6-9).

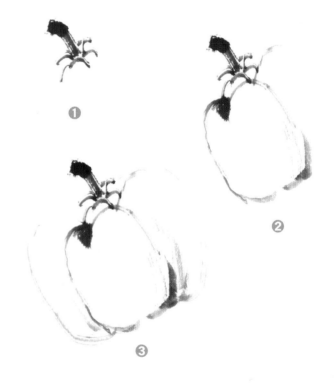

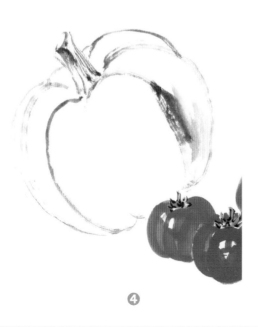

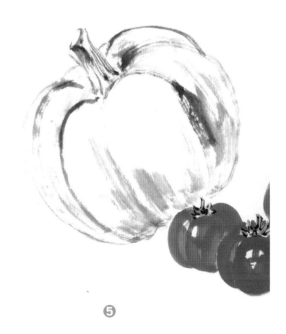

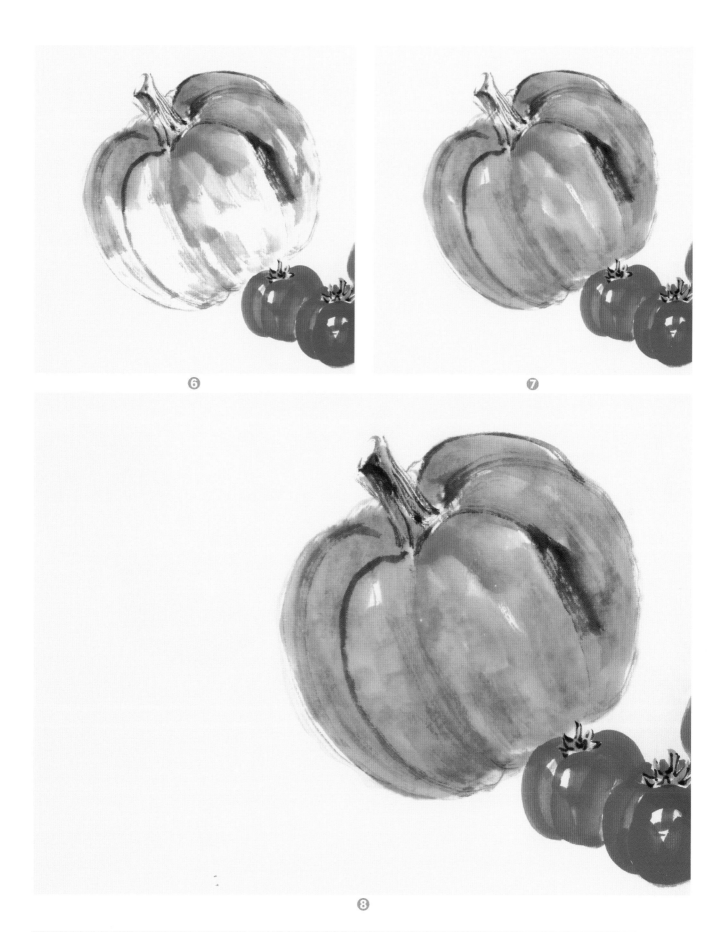

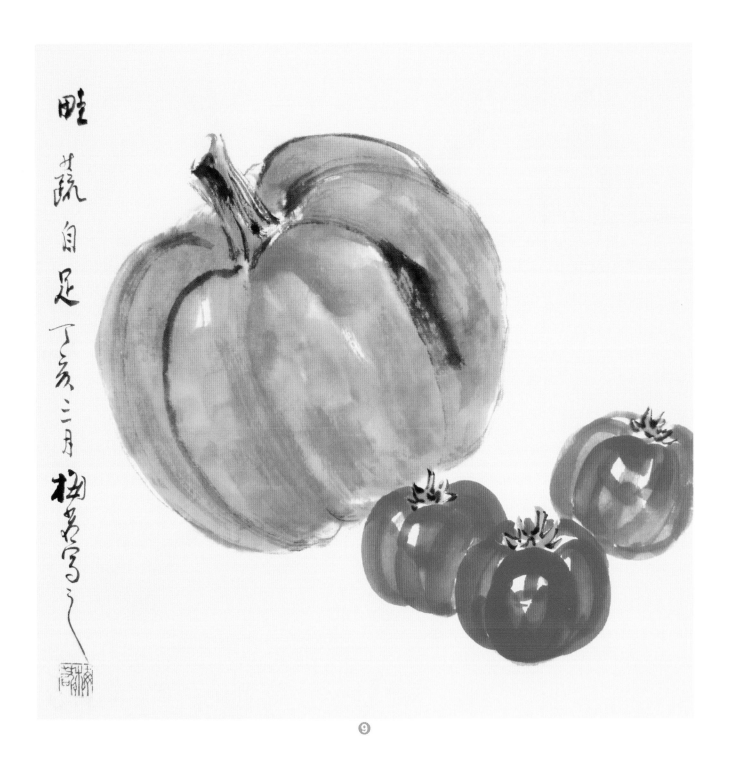

Persimmon

The larger variety is commonly known in China as the "copper basins" persimmon shaped like two basins welded together.

Painting the "copper-basins" persimmons in the *xie yi* style

1. Paint the persimmon in two strokes with a brush dipped in a mixture of orange red and eosin; paint the sepals with a mixture of dark green and ocher (Fig. 1).

2. Add the other lateral half (Fig. 2).

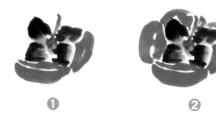

① ②

3. Add the bottom half; touch up the sepals with dark ink (Fig. 3).

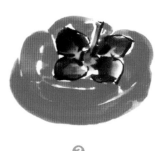

③

4. Another simpler way is to paint the persimmon from the bottom in two strokes, and then add the sepals (Figures 4-6).

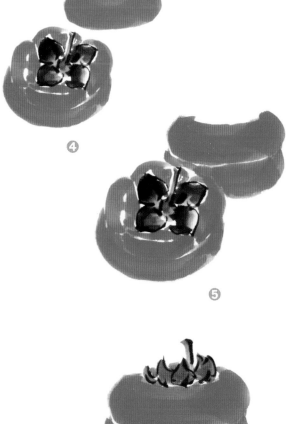

④

⑤

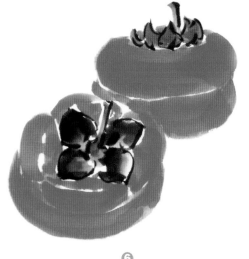

⑥

Painting the smaller variety in the *xie yi* style

There are four sepals; remember to leave highlights in the various segments (Figures 1-4).

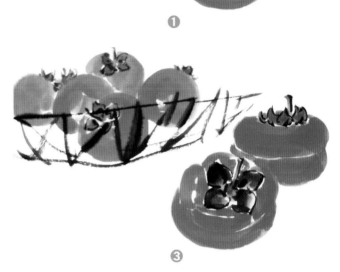

❶

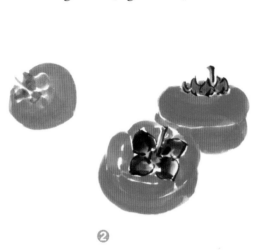

❷

❸

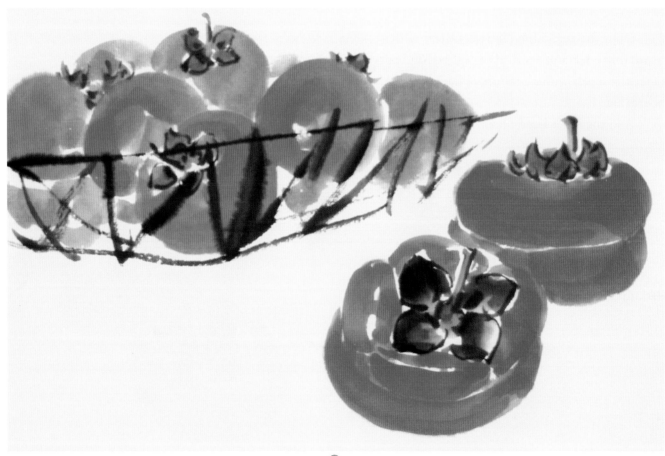

❹

Peach

The peach is popular because it symbolizes longevity. Some varieties are the honey peach, the yellow peach and the flat peach. The honey peach consists of two uneven halves with a depression between the halves.

Painting a honey peach

1. Paint the midsection of the peach with a brush soaked with clear water up to its base and tipped with eosin in side-brush strokes (Fig. 1).

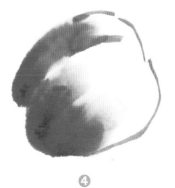

2. Tilting the brush inward so that the tip points outward to paint the edge of the peach (Fig. 2). It is a common mistake to keep the base of the brush close to the edge, which would cause bleeding and distort the shape of the peach (Fig. 3).

3. Paint the other half in centered-tip strokes, leaving the depression in the center; use the remaining red on the tip of the brush to outline the edge (Fig. 4).

❹

4. Color the bare parts on the peach in gamboge (Figures 5-6).

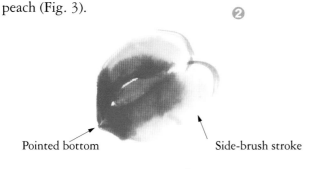

Pointed bottom Side-brush stroke

Wrong example
❸

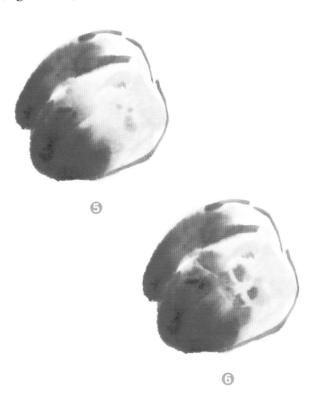

❺

❻

Painting several honey peaches pointing in various directions by employing the same technique

1. Paint two sides of the peach in three strokes with a brush soaked with water up to its base and tipped with eosin, leaving the tip of the peach and the depression in the middle (Figures 1-2).

2. Outline the bottom half. Color the bottom half with a lighter shade of gamboge (Figures 3-4).

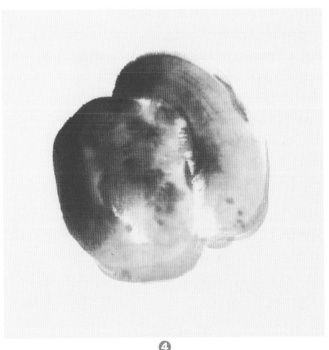

3. Add other peaches, placed at different angles. Outline a basket in dark ink to frame all the peaches (Figures 5-7).

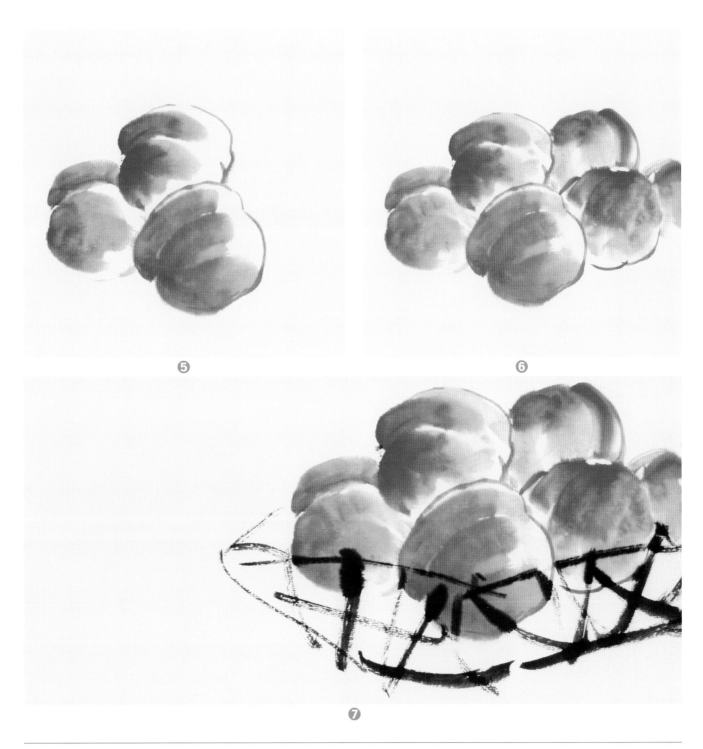

⑤

⑥

⑦

Painting yellow peaches

Dip the brush in gamboge and tip it with eosin
and follow the steps for the honey peaches (Figures
1-5).

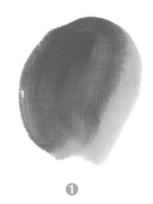

❶

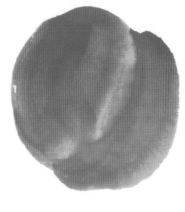

❷

❸

❹

❺

Painting flat peaches

The flat peach is also a Chinese favorite. Because of its irregular shape, the technique needs to be slightly modified (Figures 1-7).

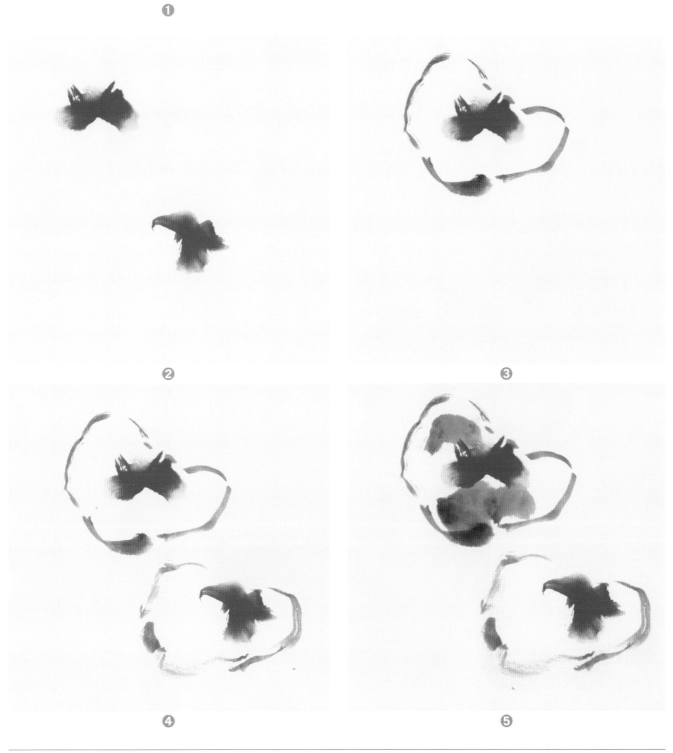

Painting a kiwi fruit
(Figures 1-7)

Example of painting peaches

Now we have a fine painting by putting together the different varieties of peaches painted by following the steps outlined above (Fig. 1).

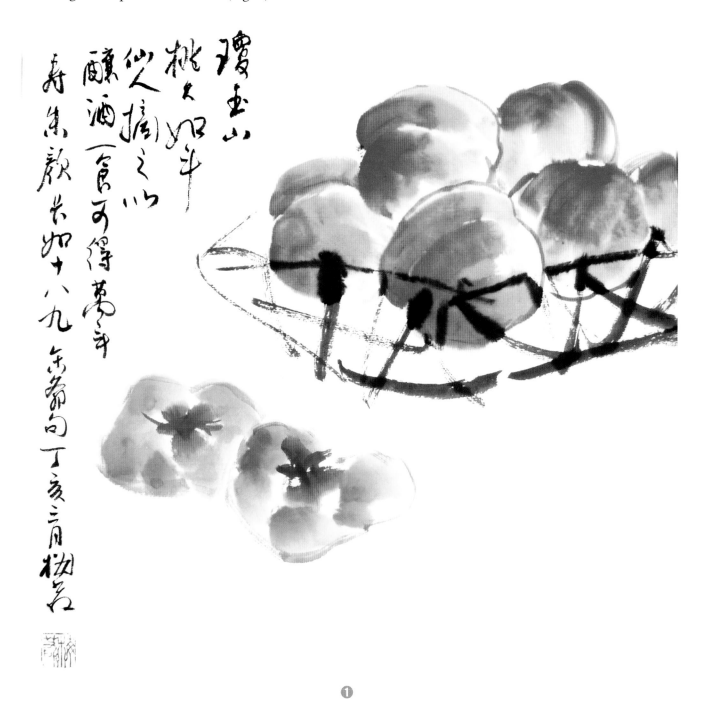

❶

Watermelon

The watermelon has an irregular round shape. It consists of a striped rind and a fleshy interior. The watermelon is relatively easy to paint except when it is cut open.

Painting a round watermelon

1. Dip the brush in dark green and tip it with malachite; paint the shape of the watermelon with the tip of the brush pointing outward and the midsection of the brush pointing inward (Figures 1-2).

①

②

2. Remember to leave highlights and nuance the ink tones to give a three-dimensional feel (Figures 3-4).

③

④

3. Paint the stripes in ink (Fig. 5).

4. Touch up the veins on the rind in side-brush strokes to give volume (Figures 6-7).

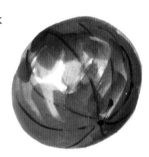

⑤

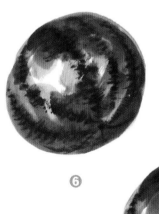

⑥

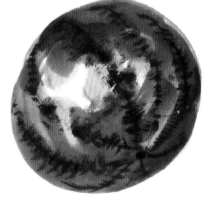

⑦

Painting watermelon section

1. Rinse the brush in clear water; tip the water-saturated brush with light eosin to paint the triangular section in side-brush strokes. Paint two sides with clear-cut edges. Do not let the ink or color run (Fig. 1).

2. The rind should be thin and ornamented with a green accent. Paint the rind with a water-filled brush dipped sparingly in a thick dark green, using a side-brush stroke (Fig. 2)

3. Use dark ink to dot in the seeds in a pattern radiating down from the tip of the triangular section to make it look more realistic. Add some leaves as accent; use "flying white" strokes to portray the dried vines (Figures 3-6).

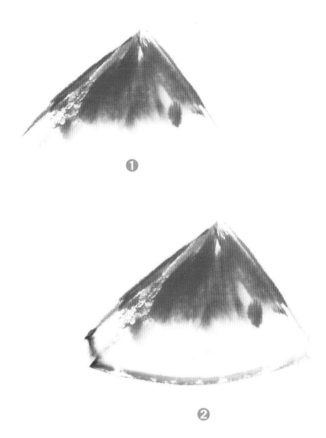

❶

❷

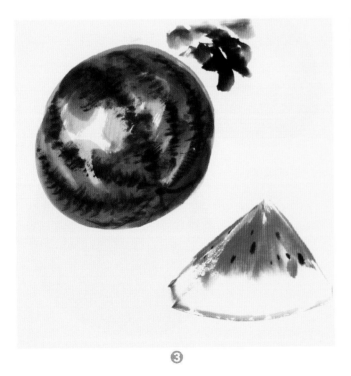

❸

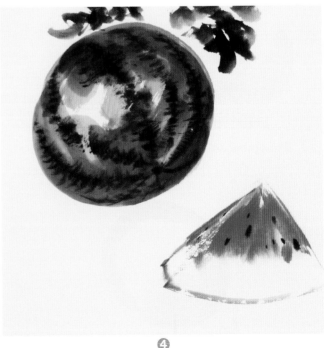

❹

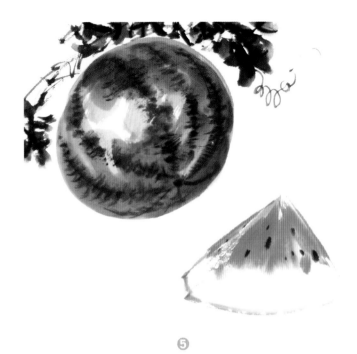

⑤

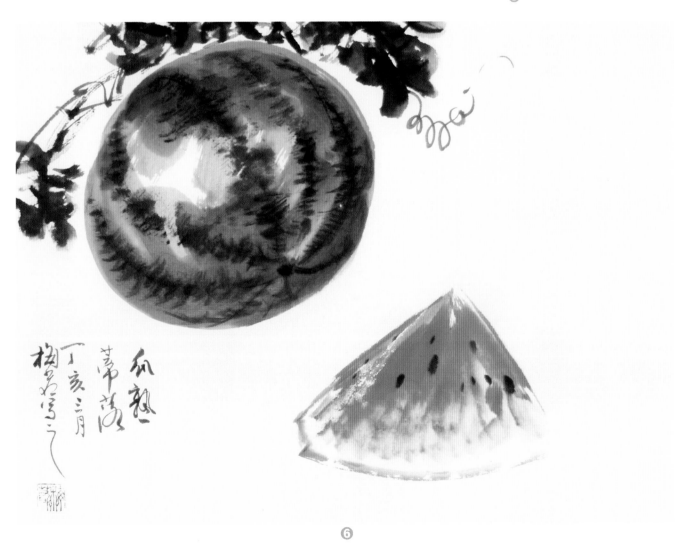

⑥

Grape and Honeydew Melon

Painting grapes

1. Make a purple by mixing cyanine and eosin. To obtain a brighter purple, mix phthalo blue with eosin. Paint from one side toward the center, then from the other side toward the center. It does not matter whether a gap is left between the two halves (Figures 1-2).

2. Vary the ink and color shading and the density of the pictorial composition (Figures 3-4).

3. Use a dry brush dipped in ink and ocher to paint the main stems that link up the grapes (Fig. 5).

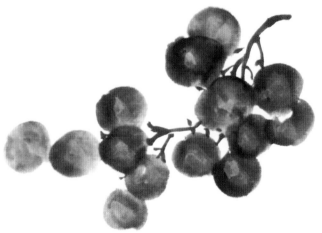

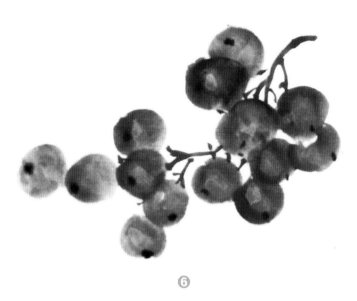

4. Before the ink dries, add white dots to the grapes to create highlights. Before the white color dries, dot the stigma scars of the grapes in dark ink, near the right edge of the grapes to the right of the main stem and the left edge of the grapes to the left of the stem (Fig. 6).

5. After completing the grapes, add a bulky element, such as a honeydew melon, to make the composition more interesting (Fig. 7).

6

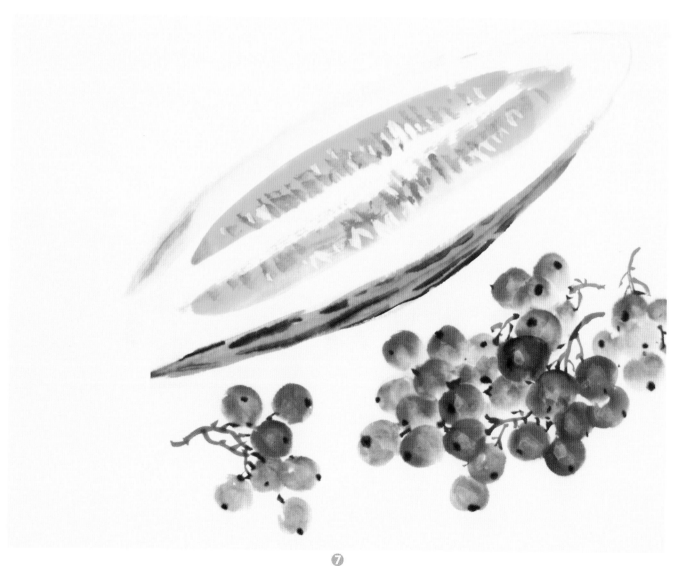

7

Painting half a honeydew melon

1. Use a water-filled, larger-size brush, dipped in gamboge and tipped with a bit of orange red to create a golden mix to paint the pulp in two strokes, leaving a "flying white" blank along the midline (Fig. 1).

2. Paint the rind in dark green mixed with some ocher; you can touch up the edge of the melon (Figures 2-3).

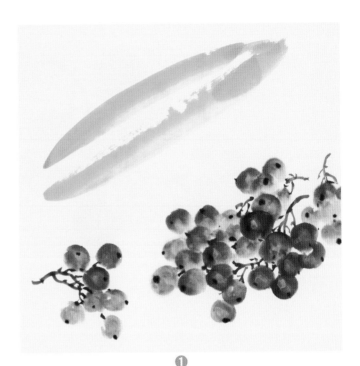

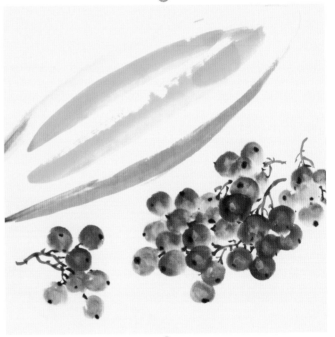

❶

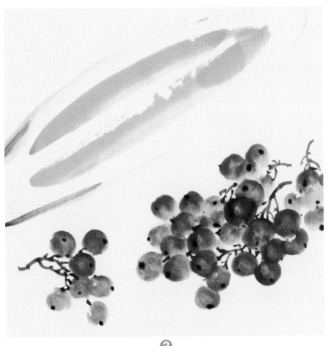

❷

❸

3. Outline the stripes on the rind in dark ink (Fig. 4).

4. Dot the middle of the fleshy part in gamboge mixed with ocher in side-brush strokes; slightly accent the deeper spots of the flesh (Figures 5-6).

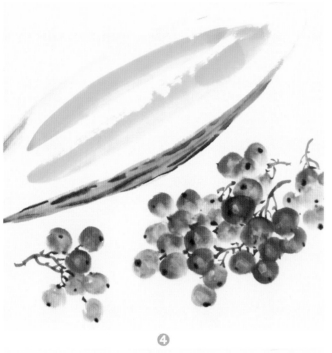

❹

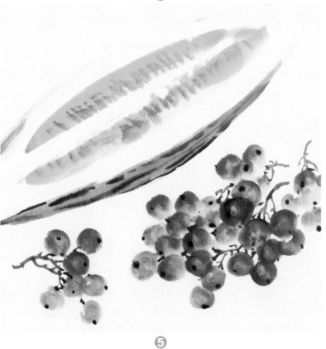

❺

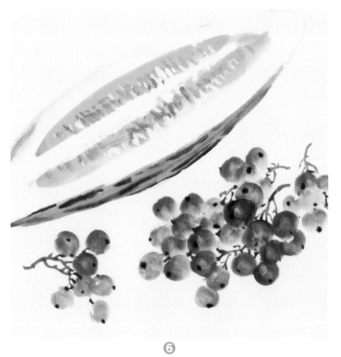

❻

5. Finish up with a few lines of verse and a
"Cornucopia of Grapes and Melons" is complete
(Fig. 7).

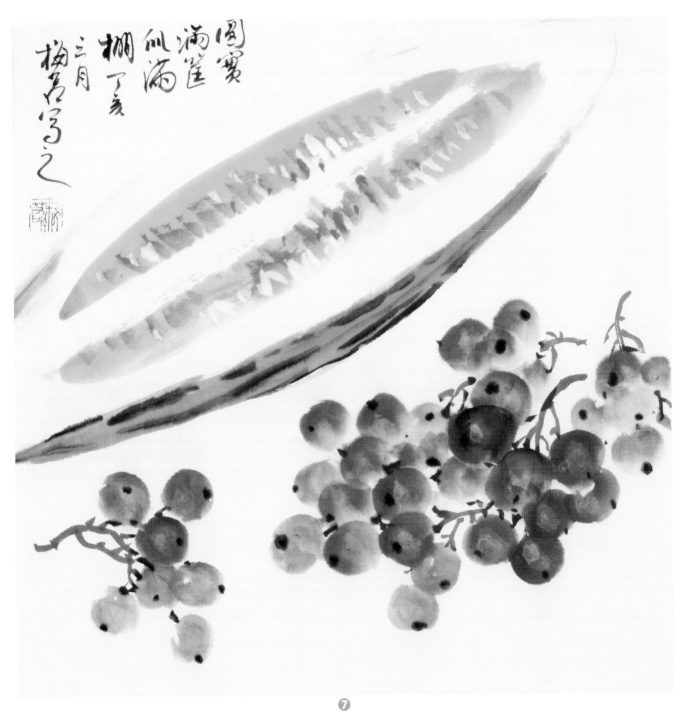

Loquat

The technique is similar to that for painting grapes, mutatis mutandis.

Painting loquats

1. The color is different, so use a brush dipped in gamboge and tipped with orange red (Fig. 1).

❶

2. Remember not to paint loquats in an overly uniform and symmetrical composition (Figures 2-3).

❷ ❸

3. Loquats are larger than grapes and their stems are thicker. Paint them in ocher mixed with ink in centered-tip strokes. Before the color dries,

dot the stigma scars in dark ink and let it bleed, because this would better communicate the downy characteristic of the stigma scars of the loquats (Fig. 4).

❹

Normally the loquats are painted without leaves. Occasionally a few leaves are added by some artists.

The loquats ripen in the fifth lunar month on the Chinese calendar, close to the traditional Duanwu Jie (Dragon boat festival) in honor of the ancient poet Qu Yuan when *zongzi* (dumplings of glutinous rice wrapped in dried bamboo leaves) are consumed, and for this reason loquats are traditionally accompanied by *zongzi* in paintings (Figures 5-6).

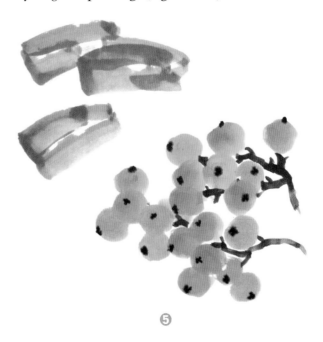

❺

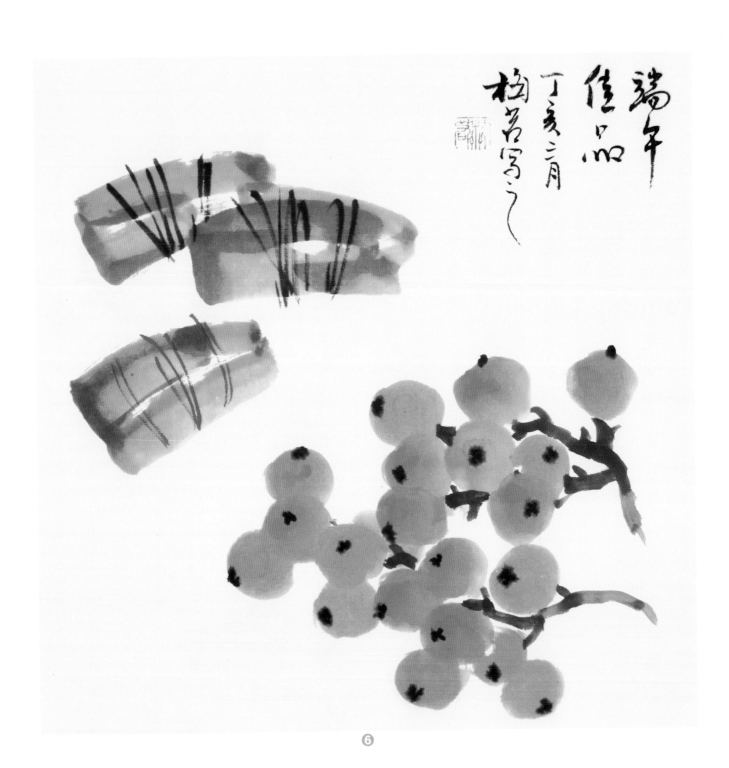

❻

Strawberry

① ②

③

Strawberries were an import into China and therefore a rare subject in traditional Chinese paintings.

Painting strawberries

1. Start by dotting an outline in bright red or eosin, then paint the shape of the strawberries (Figures 1-5).

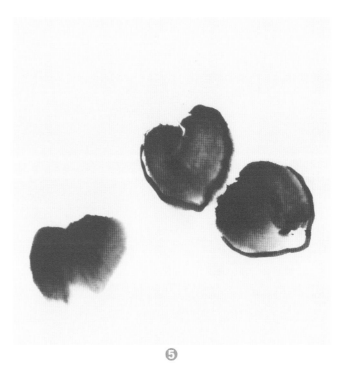

④ ⑤

2. Paint the sepals in dark green (Figures 6-7).

3. Add dots in deeper red to simulate the pitted surface of the strawberry (Figures 8-9).

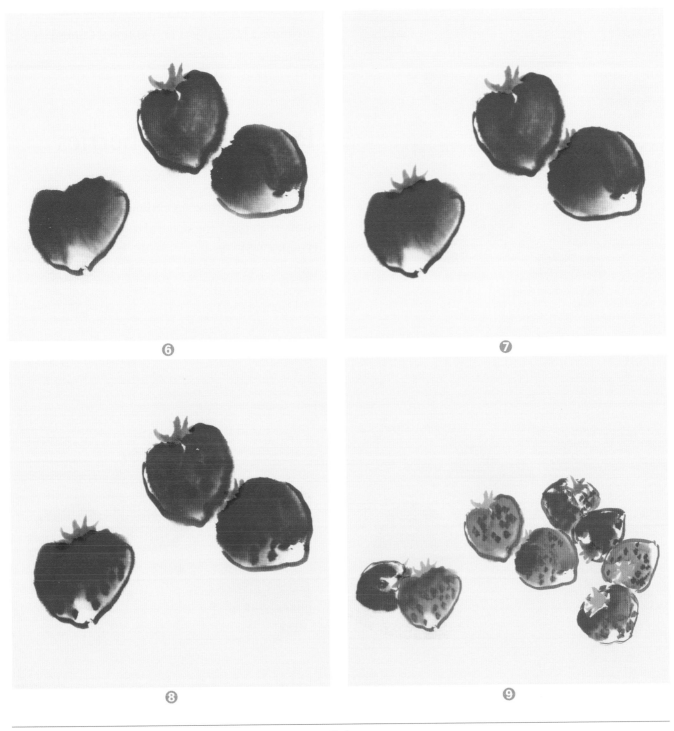

⑥

⑦

⑧

⑨

Example of strawberries with the watermelon

Sometimes watermelons are added to break the monotony of a pictorial composition of strawberries alone. Refer to the section on watermelons for the technique of painting watermelons (Figures 1-5).

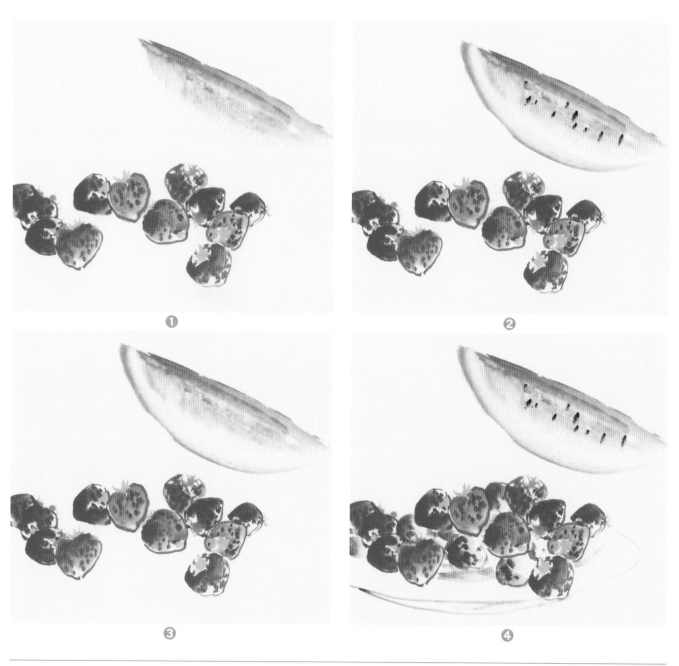

❶

❷

❸

❹

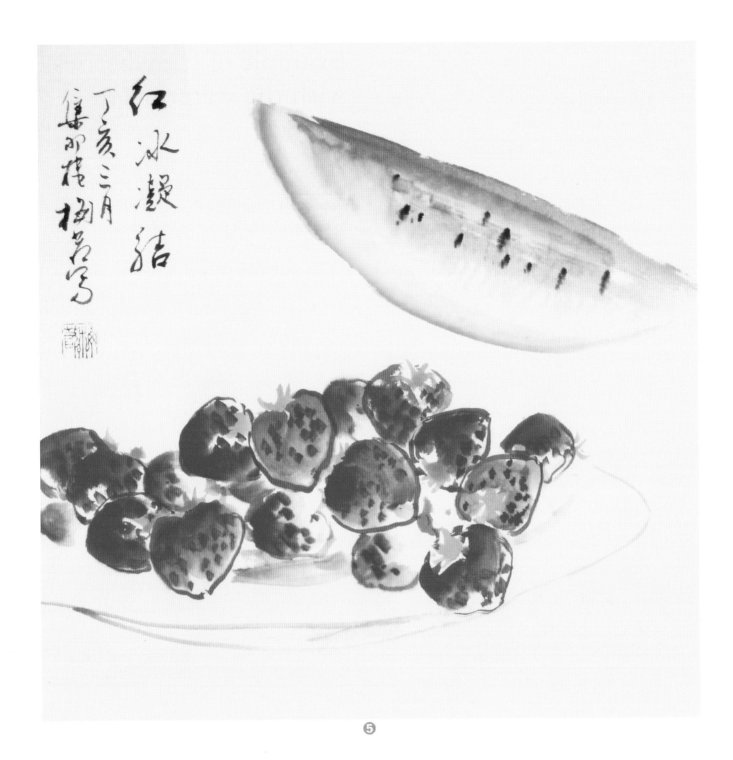

Appendices

Materials and Equipment for Chinese Painting

I. Brush

A Chinese painting brush can have soft or hard hairs or a combination of them. The brushes are made in large, medium and small sizes. The soft-hair brushes, generally of goat hairs, are very absorbent and suitable for dotting leaves and coloring. Wolf hairs make a hard brush that is tough and flexible and good for outlining leaf veins and tree trunks, among other uses. The combination brush is made of wolf and goat hairs.

The brush is composed of the tip, the "belly" (midsection), and the base (near the shaft).

II. Ink

Chinese painting is mainly done in ink, which is made from either lampblack or pine soot. Lampblack is darker, shinier and more suitable for painting. Pine soot is flatter and more suitable for calligraphy. In the past artists used to grind their ink sticks to make ink for their paintings; nowadays most artists prefer bottled ink. Choose the ink specially made for painting and calligraphy, otherwise the ink will fade after the painting is framed.

III. Paper

The paper used for Chinese painting is called *xuan* paper (also rice paper). There are two kinds of *xuan* paper: the mature *xuan* paper, which is treated with alum to make it less absorbent, good for the detailed style of Chinese painting because you can apply many coats of colors without fear of undesirable blending; and the raw *xuan* paper, which is untreated and absorbent, and suitable for the *xie yi* style because the blending of ink and color can be used by artists to produce nuanced ink tones.

IV. Inkstone

The inkstone used for Chinese painting is made from aqueous rock, which is hard and fine-textured and produces dense ink

when ground. The *Duan* inkstone, made from stone quarried in Duanxi in Guangdong Province, is the most famous of the inkstones in China. But people have turned to the more convenient bottled ink, which produces equally good results.

V. Pigments

The pigments used for Chinese painting are different from those used in western painting, and have different names. Pigments can be classified as water soluble, mineral or stone. Gamboge, cyanine, phthalocyanine, eosin and rouge are some of the water soluble paints; mineral paints include beryl blue, malachite, cinnabar and titanium white. Ocher comes under the "stone" rubric.

VI. Accessory equipment

Water bowl for rinsing brushes, felt table cover, palette etc.

Use of Ink and Brush in Chinese Painting

I. Using brush

Any stroke used in Chinese painting comprises three stages: entering the stroke, moving the brush along and exiting from the stroke. Some of the strokes are *zhong-feng* (centered-tip), *ce-feng* (side-brush), *shun-feng* ("slant-and-pull-away-from-brush-tip" or "downstream"), *ni-feng* ("slant-and-push-into-brush-tip" or "upstream"), *ti* (lift), *an* (press), *dun* (pause) and *cuo* (twist-around) etc.

The centered-tip stroke moves along the center of the ink line with the tip of the brush. To execute the side-brush stroke, the brush is held at an angle, with the tip against one side of the line (point or surface), and moves with its "belly" pressed against the paper (Fig. 1). The *shun-feng* stroke is used to paint from top downward or from left to right, while the *ni-feng* stroke moves from the bottom upward or from right to left. "Lifting" the brush as it pulls along will make a lighter line. "Press" down on the brush to make a thicker and darker line. The *dun* stroke consists in pressing the brush into the paper or grinding and rotating the brush. Several *dun* strokes constitute a *cuo* stroke.

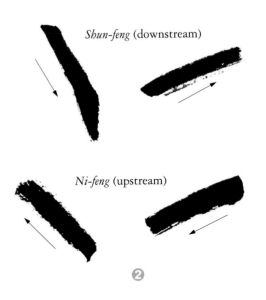

Zhong-feng (centered-tip)

Ce-feng (side-brush)

❶

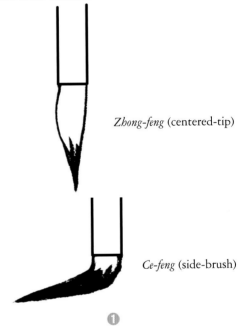

Shun-feng (downstream)

Ni-feng (upstream)

❷

II. Using ink

In Chinese painting it is important to master the use of the following five gradations of ink: dark, light, dry brush, wet brush and charred (burnt).

Dark ink: Add a small amount of water to the ink to make a dark shade;

Light ink: Increase the amount of water in the mixture to make a grayish ink;

Dry brush: A brush that contains only a small amount of water can apply either dark or light ink;

Wet brush: The brush contains more water and can also apply either dark or light ink;

Charred ink tone: Very black shading that creates a shiny black effect on the paper (Fig. 3).

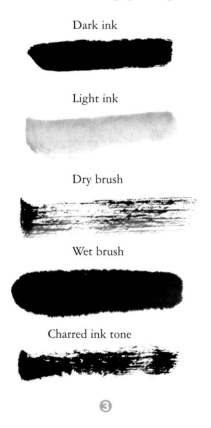

Dark ink

Light ink

Dry brush

Wet brush

Charred ink tone

❸

III. Brush and ink

Brush and ink are mutually reinforcing. The use of ink is just the other side of the brush use.

The wetness or dryness of the ink translates into the wetness or dryness of the brush to communicate the "spirit of the ink." The use of ink and the use of the brush are closely interdependent.

It is important to bear in mind these six words when using the brush: *qing* (light), *kuai* (fast), *ce* (side), *zhong*[1] (heavy), *man* (slow), *zhong*[2] (center).

Qing: Lifting the pressure on the brush while the stroke is in progress;

Kuai: Shortening the time of the stroke;

Ce: Using the *ce-feng* (side-brush) stroke;

Zhong[1]: Pressing down on the brush while the stroke is in progress;

Man: Increasing the time of the stroke;

Zhong[2]: Using the *zhong-feng* (centered-tip) stroke (Fig. 4).

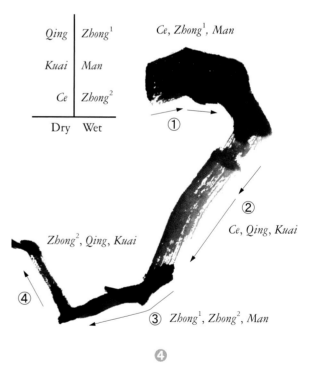

Qing	*Zhong*[1]	
Kuai	*Man*	
Ce	*Zhong*[2]	
Dry	Wet	

Ce, Zhong[1]*, Man*

①

② *Ce, Qing, Kuai*

Zhong[2]*, Qing, Kuai*

④

③ *Zhong*[1]*, Zhong*[2]*, Man*

❹

It is common sense that when the brush has been soaked in water, whatever liquid in the brush will flow down faster when the brush is held upright and will run more slowly when the brush is held at a slant. In a centered-tip stroke the upright brush is pressed down and pulled at a more leisurely pace, the ink will consequently have ample time to be

absorbed by the paper and what results is a wet stroke. If the brush is held at an angle and is not pressed as hard against the paper and is pulled at a faster pace, there is less time for the paper to take in the ink; what results then is a "flying white" (broken ink wash effect), namely a dry stroke. It is therefore essential to learn how to properly manipulate the brush and ink.

IV. Different kinds of brush strokes and ink tones in the painting

The tree trunk sample offers an analysis of the different kinds of brush strokes and ink tones employed in the painting (Fig. 4) . This is a difficult example and it takes long practice to master enough skill to successfully execute it, because it requires the use of a combination of strokes such as the side-brush, flying white, the dry-brush, the centered-tip stroke and the wet-brush stroke etc. Always pay attention to how you enter, execute and exit a stroke and remember the importance of variation in stroke speed, pressure, ink tone and wetness as well as balance in the use of strokes to compose a painting: stroke left before stroking right, stroke right before stroking left, stroke down before stroking up (Fig. 5) or stroke up before stroking down (Fig. 6).

Another technique used in Chinese painting is the *po mo* method (breaking the preceding application of ink), which consists of applying dark (light), wet ink over a preceding application of light (dark) ink before it dries. This method will impart a sense of lively variation and wetness to the painting. You can break light ink with dark ink or vice versa.

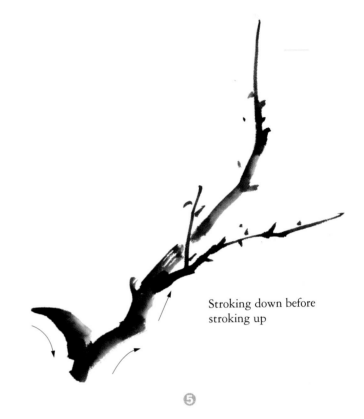

Stroking down before stroking up

⑤

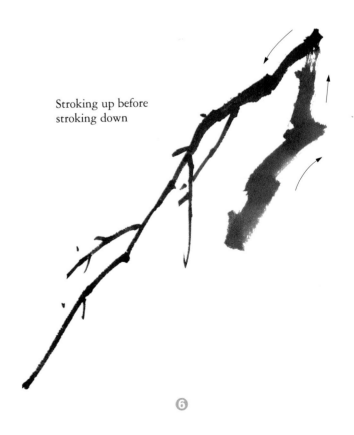

Stroking up before stroking down

⑥